W9-DDO-811

F.V.

WITHDRAWN

THE NATURE OF PHOTOGRAPHS

Published in cooperation
with the Center for
American Places,
Harrisonburg, Virginia

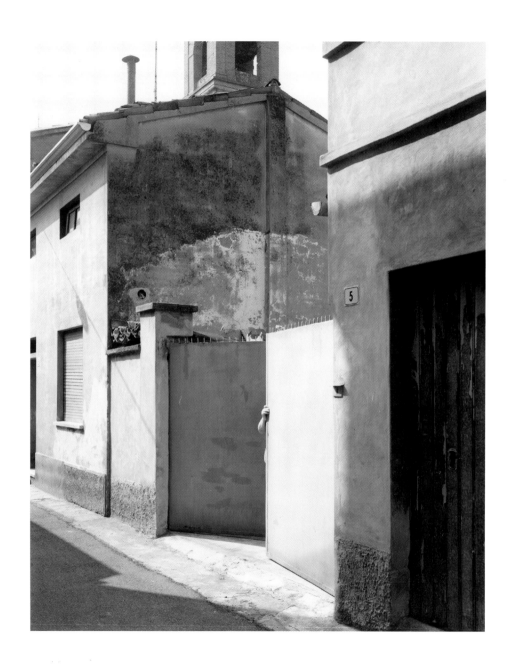

THE NATURE OF PHOTOGRAPHS

■ STEPHEN SHORE

The Johns Hopkins University Press

Baltimore and London

For Alex and Nick

The Johns Hopkins University Press

2715 North Charles Street

Baltimore, Maryland 21218-4363

The Johns Hopkins Press Ltd., London

Library of Congress Cataloging-in-Publication Data

Shore, Stephen, 1947–

 The nature of photographs / Stephen Shore.

 p. cm.

 "Published in cooperation with the Center for American Places,
Harrisonburg, Virginia"—

 ISBN 0-8018-5719-8 (alk. paper). — ISBN 0-8018-5720-1 (pbk. :
alk. paper)

 1. Composition (Photography) 2. Visual perception. 3. Photo-
graphs. I. Center for American Places (Harrisonburg, Va.) II. Title

TR179.S56 1998

770'.1'—dc21 97-19510

A catalog record for this book is available from the British Library.

CONTENTS

ix List of Photographs

xiii Foreword, by James L. Enyeart

3 Prologue

5 The Physical Level

17 The Depictive Level

55 The Mental Level

71 Mental Modeling

81 Acknowledgments

83 Photograph Credits

PHOTOGRAPHS

iv Stephen Shore, "Luzzara, Italy, 1993"

2 Robert Frank, "View from Hotel Window — Butte, Montana"

4 Robert Frank, "View from Hotel Window — Butte, Montana"

7 Anne Turyn, "12 • 17 • 1960"

9 Richard Benson, Untitled, n.d.

11 Cindy Sherman, "Untitled Film Still"

12 Edourd Baldus, "Pavillon Richelieu, Nouveau Louvre," ca. 1855

13 Bernd and Hilla Becher, "Water Towers"

14 Dieter Appelt, "The Mark on the Mirror That Breathing Makes," 1977

15 Anonymous

16 Walker Evans, "Mining Town, West Virginia, 1936"

19 C. E. Watkins, "Castle Rock, Columbia River, Oregon, 1868"

21 Lee Friedlander, "Knoxville, Tennessee, 1971"

22 André Kertész, "Dubo, Dubon, Dubonnet, Paris, 1934"

24 Zeke Berman, "Domestic Still Life, Art and Entropy," 1979

25 Nicholas Nixon, "Friendly, West Virginia, 1982"

26 Lisette Model, "Sammy's Bar, 1940"

27 Aaron Diskin, "The Shadow," 1995

29 Robert Adams, "Clear-cut along the Nahalem River, Tillamook County, Oregon"

30 Helen Levitt, "New York, ca. 1945"

33 William Eggleston, "Gulfport, Mississippi"

34 Stephen Shore, "El Paso Street, El Paso, Texas, 1975"

36 Garry Winogrand, "Texas State Fair, Dallas, 1964"

39 Larry Fink, "Studio 54, New York City, May 1977"

40 Linda Connor, "Sleeping Baby, Kathmandu, Nepal, 1980"

41 Edward Weston, "Pepper No. 29, 1930"

42 Tod Papageorge, "Zuma Beach, California, 1978"

43 Frank Gohlke, "Aftermath: the Wichita Falls, Texas, Tornado no. 10A, Maplewood Ave., near Sikes Center Mall, Looking East, April 14, 1979/Aftermath: the Wichita Falls, Texas, Tornado no. 10B, Maplewood Ave., near Sikes Center Mall, Looking East, June 1980"

44 Anonymous, [Richard Nixon the Day after the Hiss Verdict]

45 Michael Schmidt, from "Waffenruhe," 1985–87

46 P. H. Emerson, "During the Reed Harvest"

49 Robert Adams, "Outdoor Theater and Cheyenne Mountain"

51 Jan Groover, Untitled, 1985

52 Brassaï, "Graffiti"

53 Edward Weston, "Anita, Nude I, 1925"

54 Paul Caponigro, "Death Valley, California, 1975"

57 Thomas Annan, "Close, No. 61 Saltmarket"

58 William Bell, "Cañon of Kanab Wash, Colorado River, Looking South"

59 Frederick Sommer, "Glass, 1943"

60 Berenice Abbott, "Department of Docks, New York City, 1936"

61 Paul Caponigro, "Peach, Santa Fe, New Mexico, 1989"

63 Walker Evans, "Gas Station, Reedsville, West Virginia, 1936"

64 Garry Winogrand, "World's Fair, New York City, 1964"

66 Gustave Le Gray, "The Beech Tree," ca. 1856

67 William Eggleston, "Tallahatchie County, Mississippi"

68 Emmet Gowin, "Wadi, Siyagh, Petra, Jordan, 1982"

69 Dorothea Lange, "Second Born, Berkeley, 1955"

70 Alfred Stieglitz, "Poplars, Lake George, 1932"

72 Diane Arbus, "Woman on a Park Bench on a Sunny Day, N.Y.C., 1969"

73 Lee Friedlander, "Idaho 1972"

74 Fazal Sheikh, "Darmi Halake Gilo, Sololo, Kenya, 1992–93"

75 Frederick Sommer, "Virgin and Child with St. Anne and the Infant St. John, 1966"

77 Stephen Shore, "Muna, Mexico, 1990"

79 Eugène Atget, "Oriental Poppy," n.d.

FOREWORD

■ The more the medium of photography has been the irrefutable messenger of its own aesthetic core, the more that photographers, writers, and critics throughout its history have been inspired to refine the descriptive elements of its attributes. The classic example in the nineteenth century was P. H. Emerson's treatise entitled *Naturalistic Photography*, in which an attempt was made to describe both perceptual principles of lenticular vision and an aesthetic theory of photography's *unique* potential as an art form. Though flawed by its narrowness, Emerson's bold publication opened the door for photographers and other writers to attempt philosophical and dialectical texts on *the nature of photographs*, a phrase which appropriately serves as the title to this volume by Stephen Shore.

■ In the twentieth century, works by original thinkers such as John Berger, Roland Barthes, and John Szarkowski may be seen as precursors to Shore's new and pedagogically sophisticated text. These works should not be

confused with the plethora of essays and books on "reading" photographs, which are generally unsophisticated canonizations of subject and technique.

■ To some it may seem that the gradual mixing of all art media and techniques since the 1960s would preclude the need for arguing concern for artistic photographic vision, especially when artists such as Robert Rauschenberg, Sigmar Polke, John Baldasarri, Barbara Kruger, and Cindy Sherman have so successfully exploited photography for qualities other than its inherent aesthetics. But the issues addressed in this book are not directly related to the issues of artists who *use* photography for other ideas. Rather, Shore's intent is aimed at those artists, students, and advocates of photography who remain deeply impassioned by the creative apprehension of the photograph itself. Shore's text begins with the basic explanation of what constitutes a photograph as an object and as a work of art. It rightly speaks to the reader from the presumption of the photograph as an aesthetic object and not as a tool of industry or trade. This allows Shore to direct his discussion at the reader's understanding of the highest visual standard, which can then be applied to snapshots or other forms of photography as a kind of means testing for appreciation.

■ There are writers who have sought the same visual concordance as Shore between seeing as an instrument of vision and seeing as a revelation of the vision of artists. John Berger's *Ways of Seeing* comes closest to bringing words and images

into the kind of innovative relationship that establishes visual language as a priori to the arts. His book from 1972 consists of four essays with words and images and three essays with images only, with the strictly visual essays expected to communicate on par with the traditional essays. Yet, he calls into question our ability to see anything outside our learned assumptions about art (beauty, truth, civilization) and speaks of the medium of a given art form as being in collusion with the material nature of our experience in life. Shore has taken another path, using words and images, to reveal that it is possible for visual language to inform and reform our learned assumptions. In his prologue Shore reveals how a photograph functions by providing a visual grammar that elucidates the photograph's meaning.

■ Parallel ideas are found in Roland Barthes's 1981 work *Camera Lucida, Reflections on Photography*, in which he attributes to photography not only the power of a self-described linguistic ability but actual presence of mind, maintaining that "nothing eidetically distinguishes a photograph, however realistic, from a painting. 'Pictorialism' is only an exaggeration of what the photograph thinks of itself" (31). But Barthes, like Berger, turns his argument toward philosophy and away from process, sug-gesting that one should close one's eyes and let the mind be, as Cezanne said, a "sensitive plate" in order to see. While these arguments offer sympathetic sustenance to Shore's interest

in the nature of photographs with their own grammar and syntax, they are simultaneously departures by way of their judgmental stances. Shore's book is unique in its antiseptic distance from proselytization. In its own way his text is as lean and elegant as his photographs, committed to the discovery of photography's "seductive illusion" of transformed reality, not the redefined reality of Berger's "learned assumptions" or Barthes's poignant acci-dents of reality, which he called "punctum."

■ The book that most closely approaches the intent of Shore's is *The Photographer's Eye*, published by John Szarkowski in 1966. The fundamental method of dividing the whole of photography into discrete divisions for critical analysis is similar in both texts. Even two of the "categories" are the same: frame and time. The major difference lies in Shore's concentration on the photograph and Szarkowski's focus on the photographer.

■ Shore divides his book into four areas, two dealing with the physicality of the photograph and two devoted to cognitive issues of perception. His text goes beyond those of his precursors in penetrating both the process of seeing and the construction of photographs. This is a book that will make the subtleties of learning to see photographs as unique visual objects apparent and at the same time will connect language to vision in a more appreciative way.

■ It is of no little importance that this book was created by an artist of international acclaim, a photographer whose style

is inimitable and, yet, held up as a model for a new generation of photographers by his peers. Hilla and Bernd Becher have said of Shore that he has been a major influence on their thinking about photography and what they teach about photography. They and other artists have spoken of the "precision" in his work, and it is this same sense of precision that Shore has brought to his exploration of photographic perception and visual thinking.

Shore's text is written so clearly and the ideas presented so aptly through the photographs of the major photographers he has selected for reproduction that students, artists, and arts advocates will benefit from it both as an artist's book and as a primary tool for critical analysis and understanding of photography in general.

JAMES L. ENYEART
Director of the Marion Center of Photographic Art, College of Santa Fe

THE NATURE OF PHOTOGRAPHS

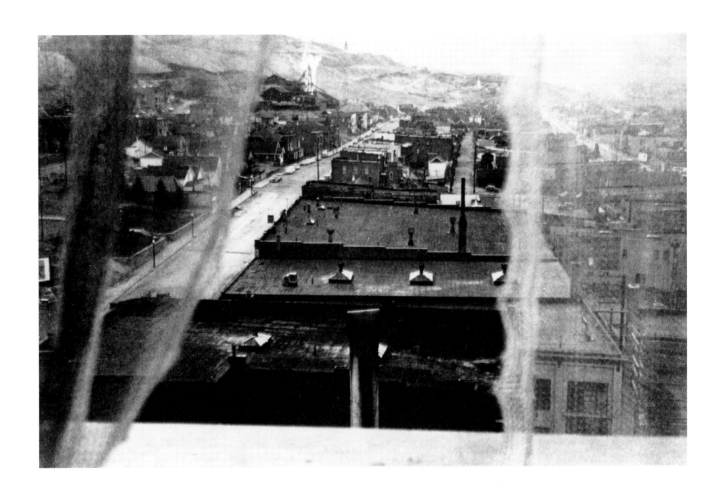

PROLOGUE

■ How is this photograph different from the actual scene that Robert Frank saw as he stood in his Butte hotel room and looked out on this depressed mining town in the northern Rockies? How much of this image is a product of lenses, shutters, and emulsions? What are the characteristics of the medium that establish how a photograph looks?

■ This book explores ways of understanding the nature of photographs, that is, how photographs function—and not only the most elegant or graceful photographs, but all photographs made with a camera and printed directly from the negative. All photographic prints have qualities in common. These qualities determine how the world in front of the camera is transformed into a photograph; they also form the visual grammar that elucidates the photograph's meaning.

■ A photograph can be viewed on several levels. To begin with, it is a physical object, a print. On this print is an image, an illusion of a window onto the world. It is on this level that we usually read a picture and discover its content: a souvenir of an exotic land, the face of a lover, a wet rock, a landscape at night. Embedded in this level is another that contains signals to our mind's perceptual apparatus. It gives "spin" to what the image depicts and how it is organized.

■ The aim of this book, then, is not to explore photographic content, but to describe the physical and formal attributes of a photographic print that form the tools a photographer uses to define and interpret that content.

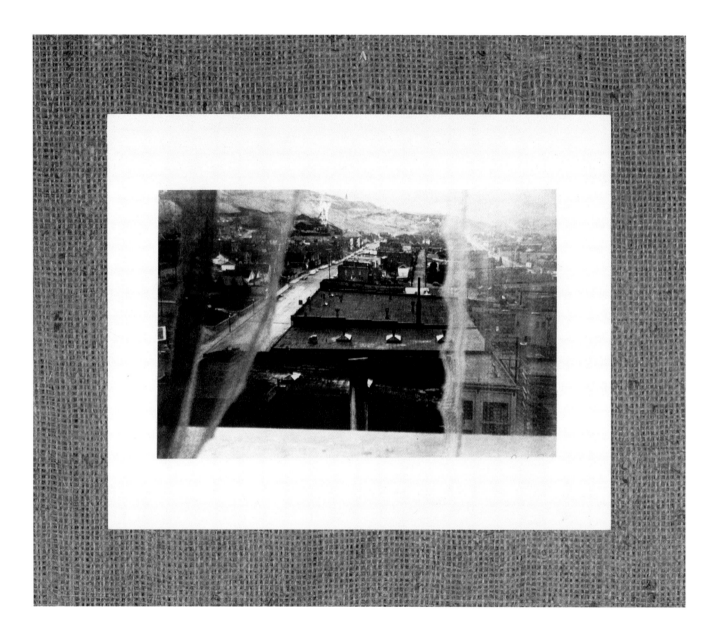

THE PHYSICAL LEVEL

■ A photographic print is, in most instances, a base of paper, plastic, or metal that has been coated with an emulsion of light-sensitive metallic salts or metallic salts coupled with vegetable or metallic dyes. In some prints, the base is coated directly with dyes, pigments, or carbon. A photograph is flat, it has edges, and it is static; it doesn't move. Although it is flat, it is not a true plane. The print has a physical dimension.

■ These physical and chemical attributes form the boundaries that circumscribe the nature of the photograph. These attributes impress themselves upon the photographic image. The physical qualities of the print determine some of the visual qualities of the image. The flatness of the photographic paper establishes the plane of the picture. The edges of the print demand the boundedness of the picture. The type of black-and-white emulsion determines the hue and tonal range of the print. The type of base determines its texture. Color dyes and pigments expand a photograph's palette and add a new level of descriptive information to the image.

■ The tonal range of a black-and-white print is affected by the type of emulsion the print is made with. The composition of the film emulsion, the chemistry of the film and print developers, and the nature of the light source from which the print is made also determine the way shadows, mid tones, and highlights are described by the print; they determine how many shades of gray the print contains and whether these tones are compressed or separated.

■ This reproduction of a print by Richard Benson has an exceptionally long tonal scale with subtle, clear, beautiful separation of the low values. The original print is acrylic paint applied to aluminum. It was produced from eight halftone separations made from the original negative.

■ As an object, a photograph has its own life in the world. It can be saved in a shoebox or in an album or in a museum. It can be reproduced as information or as an advertisement. It can be bought and sold. It may be regarded as a utilitarian object or as a work of art. The context in which a photograph is seen affects the meanings a viewer draws from it.

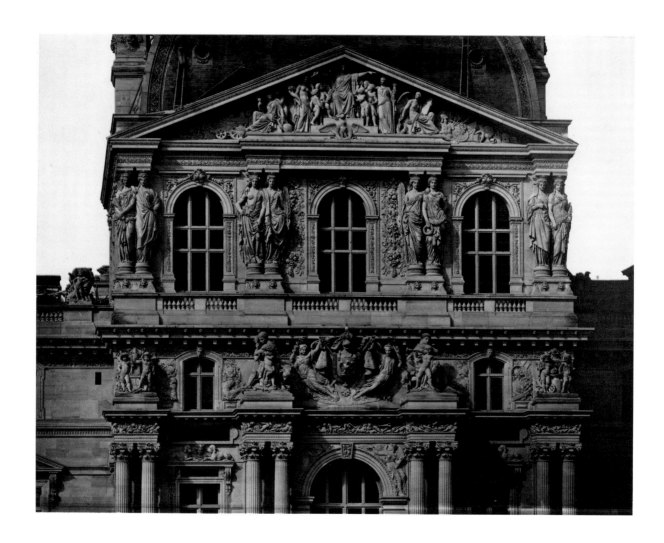

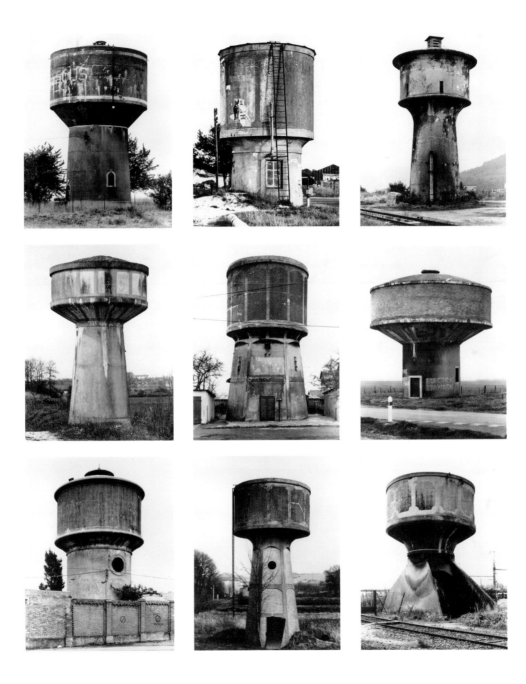

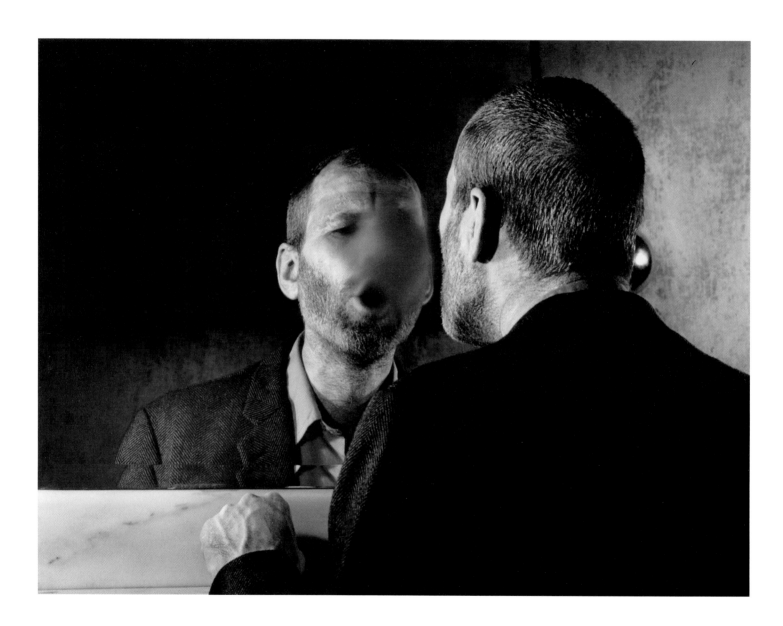

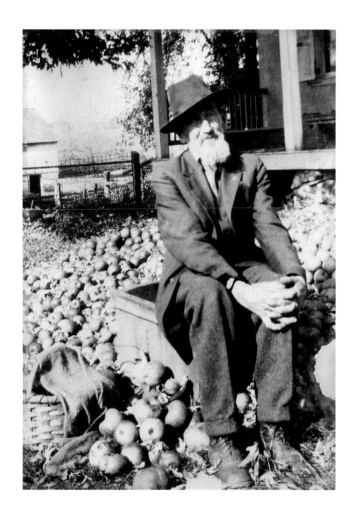

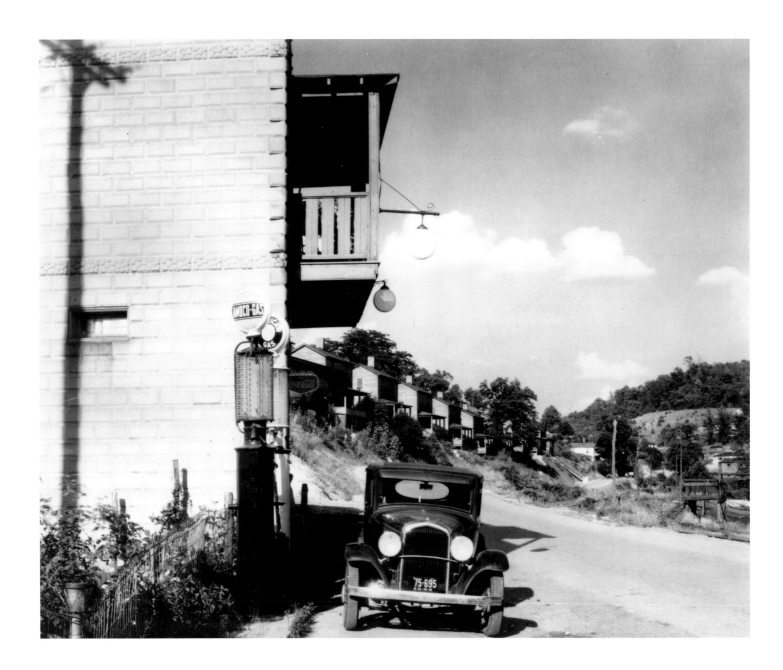

THE DEPICTIVE LEVEL

■ The photographic image depicts, within certain formal constraints, an aspect of the world. This photograph by Walker Evans depicts a store, gas pumps, a car, a road, hills and houses, sky. It also depicts receding space.

■ The formal character of the image is a result of a range of physical, chemical, and optical factors. These include the film (black-and-white or color), the focal length of the lens, and the chemistry and materials used for processing and printing. But on the depictive level there are four central ways in which the world in front of the camera is transformed into the photograph: flatness, frame, time, and focus. They define the picture's depictive content and structure. They form the basis of a photograph's visual grammar. They are responsible for a snapshooter's "mistakes": a blur, a beheading, a jumble, an awkward moment. They are the means by which photographers express their sense of the world, give structure to their perceptions and articulation to their meanings.

FLATNESS

■ The first means of transformation is flatness. The world is three dimensional; a photographic image is two dimensional. Because of this flatness, the depth of depictive space always bears a relationship to the picture plane. The picture plane is a field upon which the lens's image is projected. A photographic image can rest on this picture plane and, at the same time, contain an illusion of deep space.

■ Photographs have (with the exception of stereo pictures) monocular vision —one definite vantage point. They do not have the depth perception that our binocular vision affords us. When three-dimensional space is projected monocularly onto a plane, relationships are created that did not exist before the picture was taken. Things in the back of the picture are brought into juxtaposition with

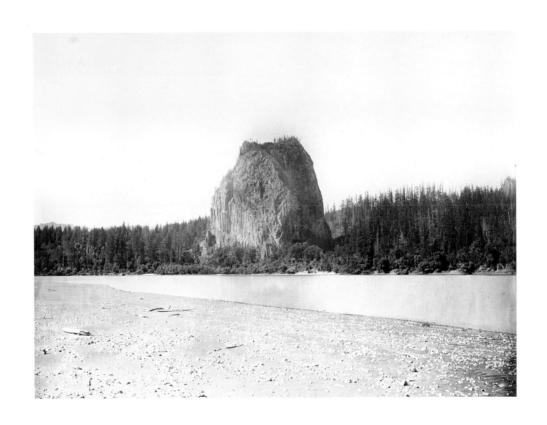

things in the front. Any change in the vantage point results in a change in the relationships. Anyone who has closed one eye, held a finger in front of his or her face, and then switched eyes knows that even this two-inch change in vantage point can produce a dramatic difference in visual relationships.

■ To say that new relationships are created does not mean that the yield sign and cloud in this photograph by Lee Friedlander were not there in front of the camera, but that the visual relationship between them, the cloud sitting like cotton candy on top of the sign, is a product of photographic vision.

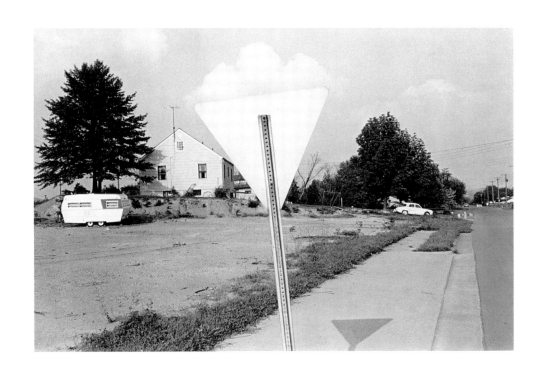

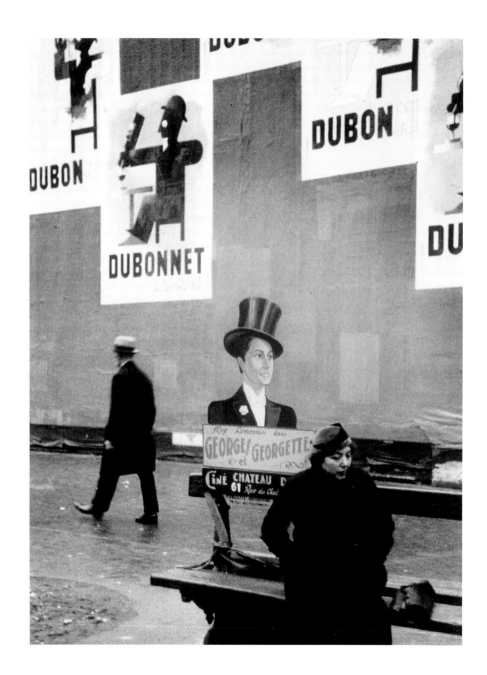

■ In the field, outside the controlled confines of a studio, a photographer is confronted with a complex web of visual juxtapositions that realign themselves with each step the photographer takes. Take one step and something hidden comes into view; take another and an object in the front now presses up against one in the distance. Take one step and the description of deep space is clarified; take another and it is obscured. In bringing order to this situation, a photographer solves a picture more than composes one.

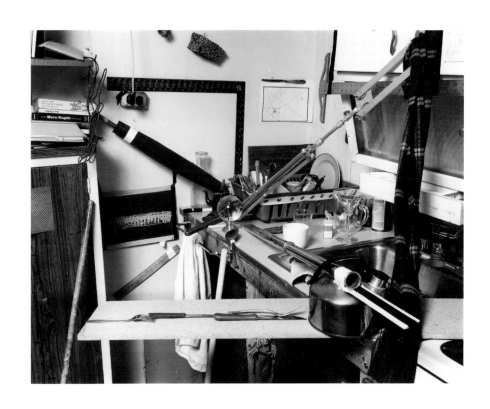

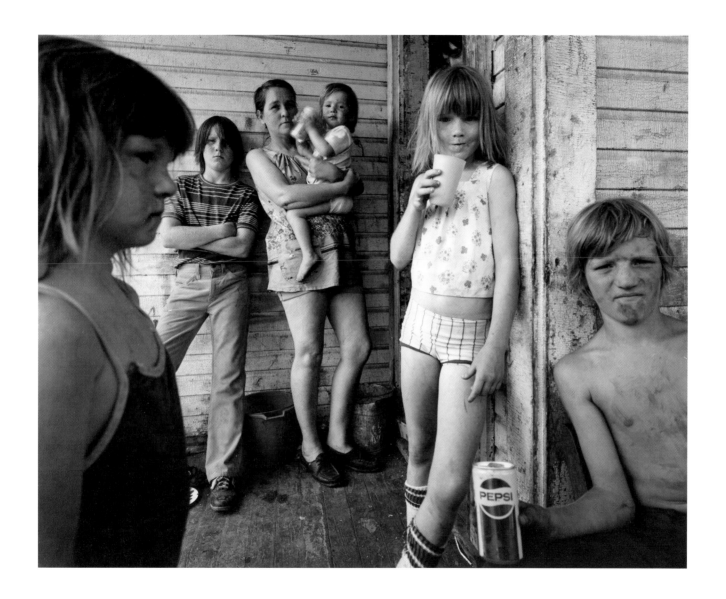

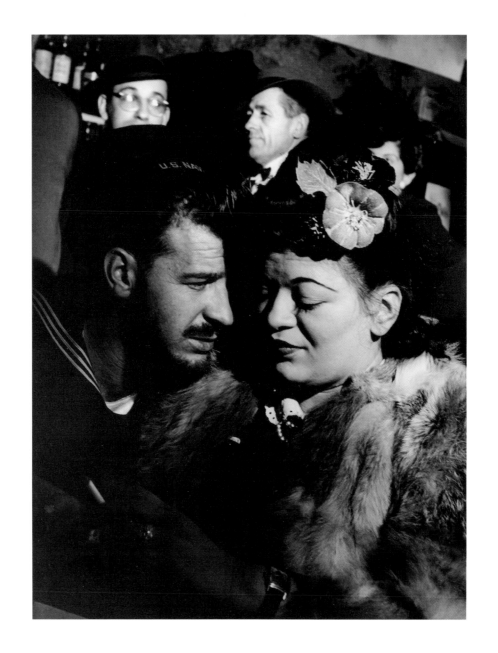

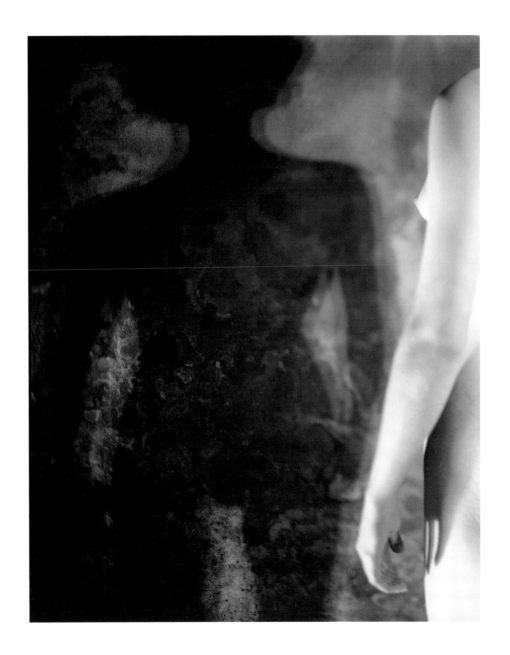

FRAME

■ The next transformative element is the frame. A photograph has edges; the world does not. The edges separate what is in the picture from what is not. Robert Adams aimed his camera down a little bit and to the right, included a railroad track in this photograph of a partially clear-cut Western landscape, and sent a chilling reverberation through the image's content and meaning. The frame corrals the content of the photograph all at once. The objects, people, events, or forms that are in the forefront of a photographer's attention when making the fine framing decisions are the recipients of the frame's emphasis. The frame resonates off them and, in turn, draws the viewer's attention to them.

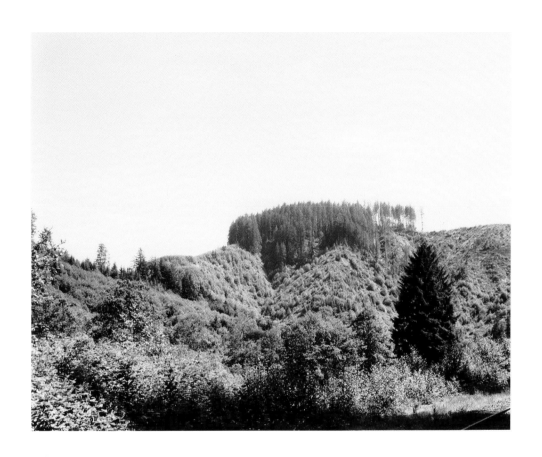

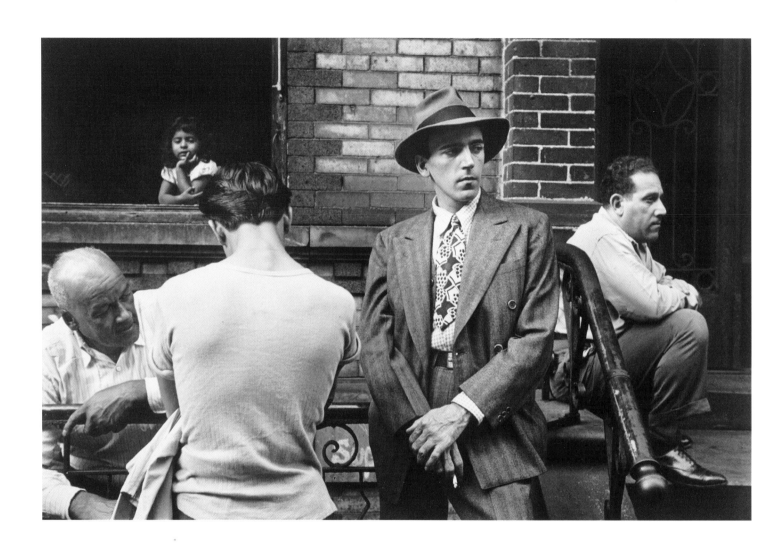

■ Just as monocular vision creates juxtapositions of lines and shapes within the image, edges create relationships between these lines and shapes and the frame. The relationships that the edges create are both visual and "contentual."

■ The men in the foreground of this photograph by Helen Levitt bear a visual relationship not only to each other, but also to the lines of the frame. The frame energizes the space around the figures. These formal qualities unite the disparate action of this picture—the seated man with his stolid stare, the languid dialogue of the two men on the left, and the street-wise angularity of the central figure— into the jazzy cohesion of 1940s New York City street life.

■ For some pictures the frame acts passively. It is where the picture ends. The structure of the picture begins within the image and works its way out to the frame.

■ As the street in this photograph by William Eggleston leads to a pine wood beyond the sub-division's boundaries and incorporates this borrowed scenery into its environment, so the photograph's structure incorporates this residential setting and implies a world continuing beyond its edges.

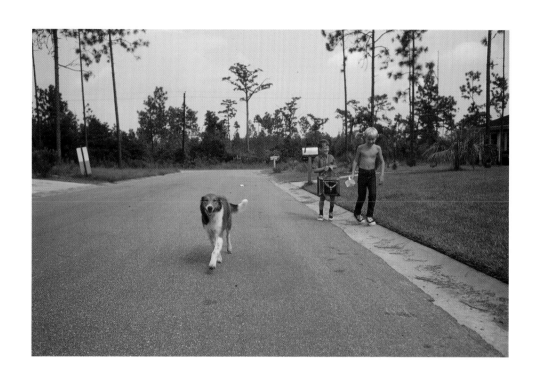

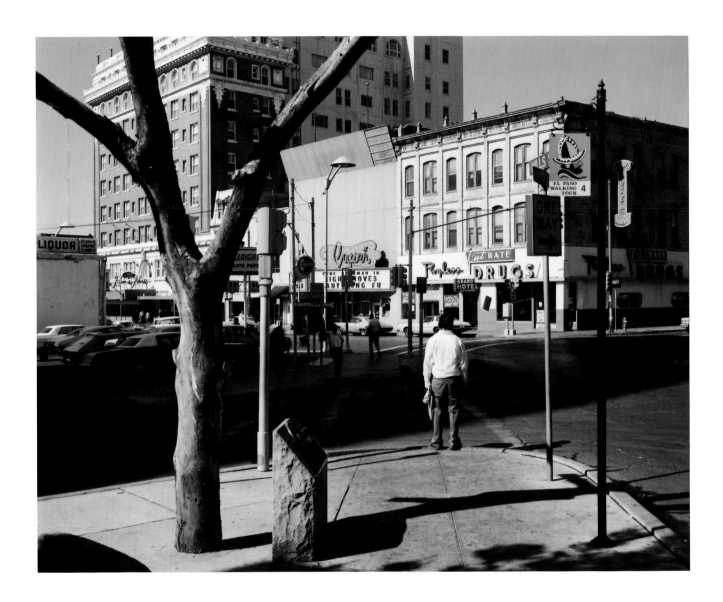

■ For some pictures the frame is active. The structure of the picture begins with the frame and works inward.

■ Although we know that the buildings, sidewalks, and sky continue beyond the edges of this urban landscape, the world of the photograph is contained within the frame. It is not a fragment of a larger world.

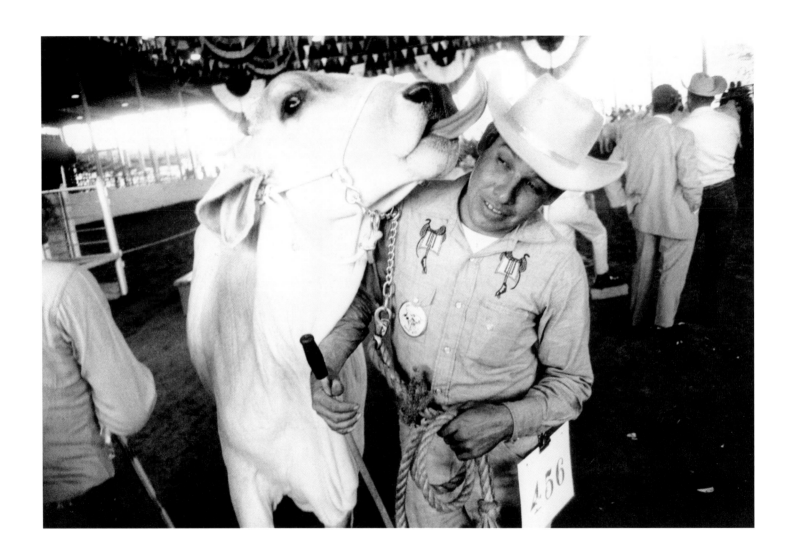

36

TIME

■ Someone saying "cheese" when having a portrait made acknowledges unconsciously the way time is transformed in a photograph. A photograph is static, but the world flows in time. As this flow is interrupted by the photograph, a new meaning, a photographic meaning, is delineated.

The reality is a person saying "cheese." The camera, bearing mute witness, depicts a person smiling—perhaps a shallow, lifeless smile like one in a yearbook portrait or a ribbon-cutting ceremony, but a smile nonetheless. Say "crackers" and the camera will see a sneer.

■ At the Texas State Fair a steer was swinging his head back and forth and flicking his tongue. His handler was ducking, trying to avoid the beast. Amidst the flux of all this motion, there was one instant, one two-hundred-fiftieth of a second, when, seen from a single vantage point and recorded on a static piece of film, the steer's tongue and the brim of his handler's Stet-

son met in perfect symmetry; an instant that, as quickly as it arose, dissolved back into disorder.

■ Two factors affect time in a photograph: the duration of the exposure and the static nature of the print and film. Just as a three-dimensional world is transformed when it is projected onto a flat piece of film, so a fluid world is transformed when it is projected onto a static piece of film. The exposure has a duration, what John Szarkowski in *The Photographer's Eye* called "a discrete parcel of time."

■ The duration of the exposure could be . . .

one ten-thousandth
of a second . . .

Frozen time: an exposure
of short duration, cutting
across the grain of time,
generating a new moment.

or two seconds . . .

Extrusive time: the movement occurring in front of the camera, or movement of the camera itself, accumulating on the film, producing a blur.

or six minutes.

Still time: the content is at
rest and time is still.

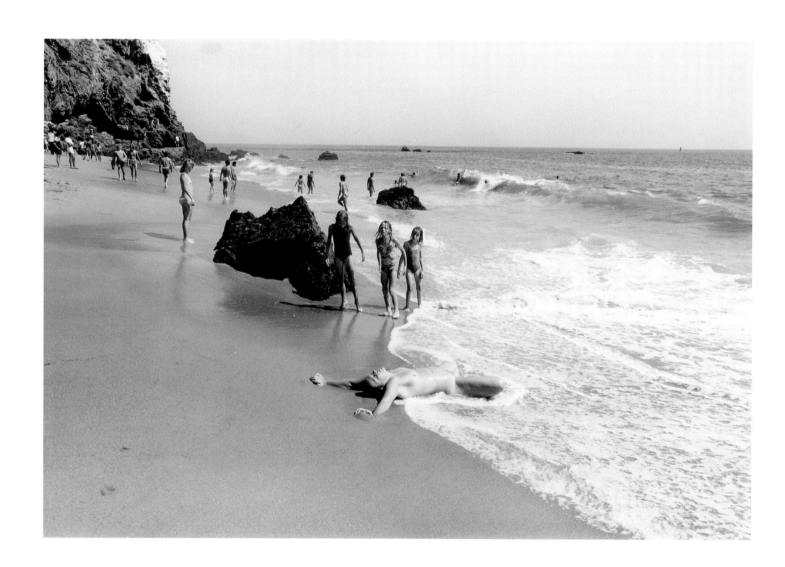

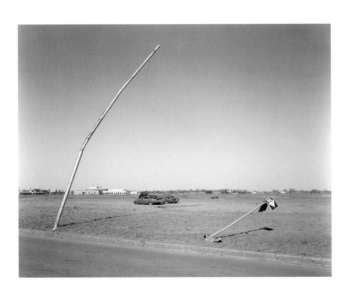 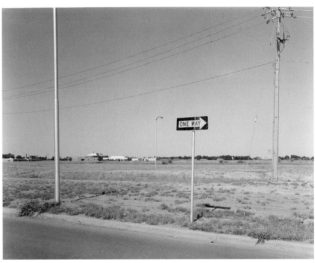

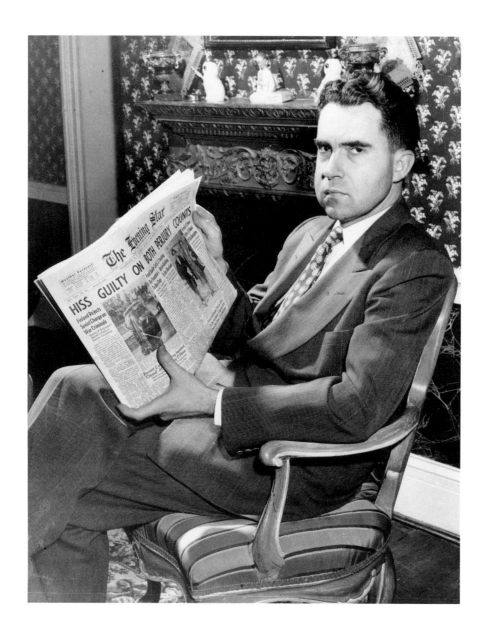

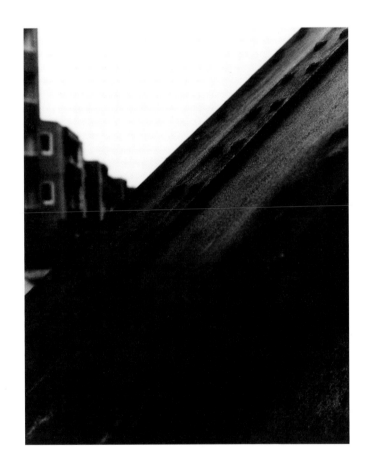

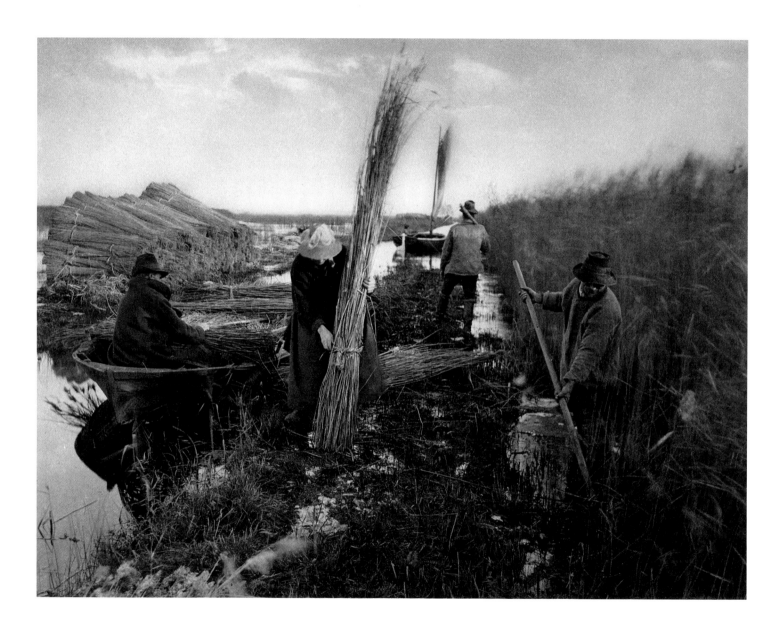

FOCUS

■ Focus is the fourth major transformation of the world into a photograph. Not only does a camera see monocularly from a definite vantage point, it also creates a hierarchy in the depictive space by defining a single plane of focus. This plane, which is usually parallel with the plane of the film, gives emphasis to part of the picture and helps to distill a photograph's subject from its content.

■ In this photograph by P. H. Emerson, the shallow area in focus—the image's depth of field—draws the viewer's awareness immediately to the three reed harvesters in the foreground. It isolates them from the fourth harvester and from the marshes in the background. The plane of focus acts as the edge of our attention cutting through the scene.

■ Examine this photograph by Robert Adams. Move your attention from the bottom edge, back through the parking lot, to the movie screen. From the screen, move your attention to the mountain to its right and from there to the sky.

■ Follow the same path through the picture, but now be aware that as your eye moves back through the parking lot—as your attention recedes through the depictive space—you have a sensation of changing focus, your eyes focusing progressively farther away.

■ Notice that as your attention moves from the screen to the mountain there is little or no change of focus.

■ Notice that as your attention moves from the mountain to the sky there is a shift of focus, but now, instead of moving back, your focus is seemingly moving forward, coming closer.

■ Notice that the direction and speed of your refocusing is not tied to the recession in depictive space. The clouds may be

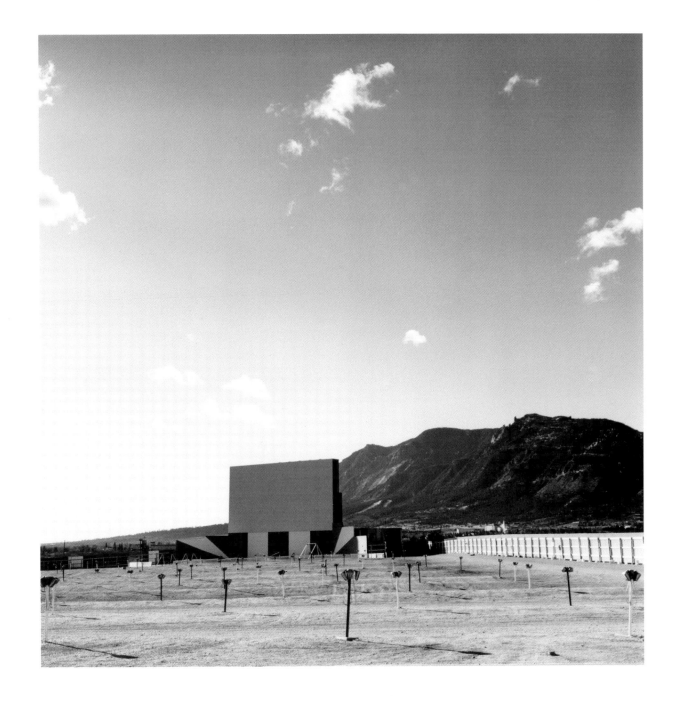

farther away than the movie screen, but your focus moves closer.

■ While with most cameras the lens is attached to a rigid camera body and so bears a fixed rela- tionship to the film, with a traditional view camera the lens, which is attached to flexible bellows, can be pivoted sideways or up and down. This allows the plane of focus to be manipulated so that it is no longer parallel to the plane of the film. It can even run perpendicular to the plane of the film, as in this still life by Jan Groover.

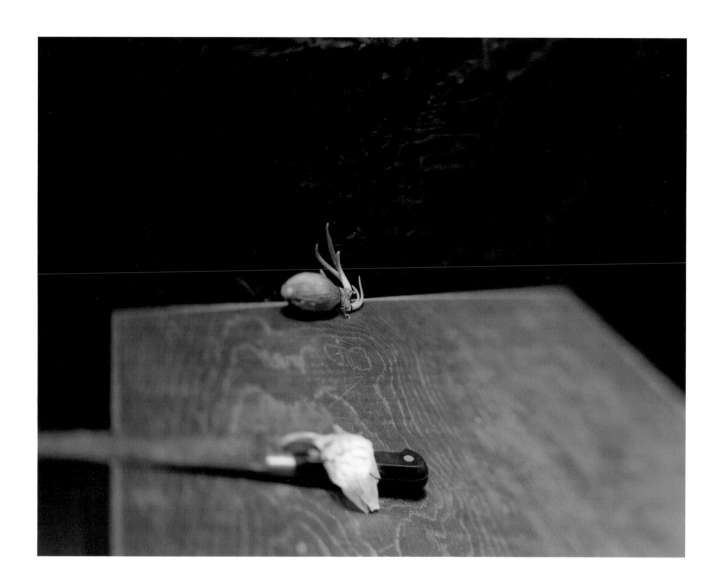

■ The spatial hierarchy generated by the plane of focus can be eliminated only by photographing a flat subject that is itself parallel to the film.

■ The hierarchical emphasis created by the plane of focus can be minimized

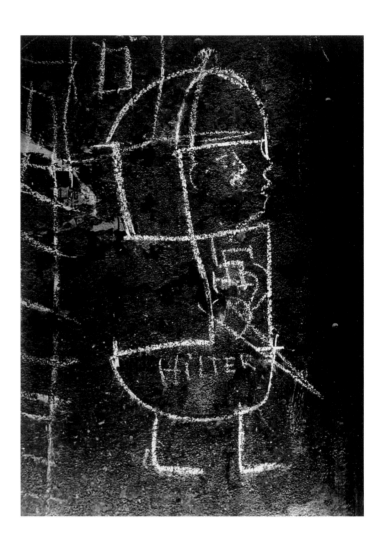

by increasing the depth
of field. But there is still
one plane that is in focus,
with space before and be-
hind rendered with dimin-
ishing sharpness. There
is a gravitation of atten-
tion to the plane of focus.
Attention to focus concen-
trates our attention.

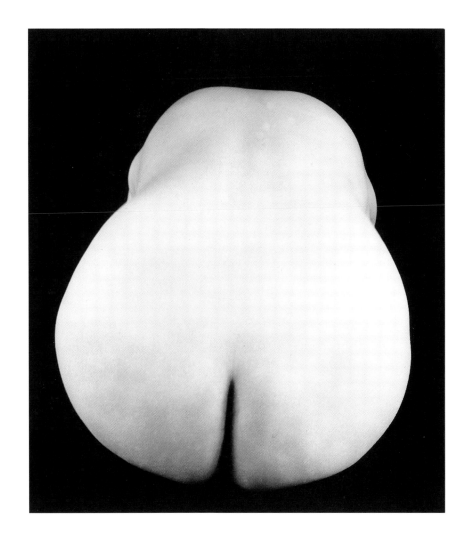

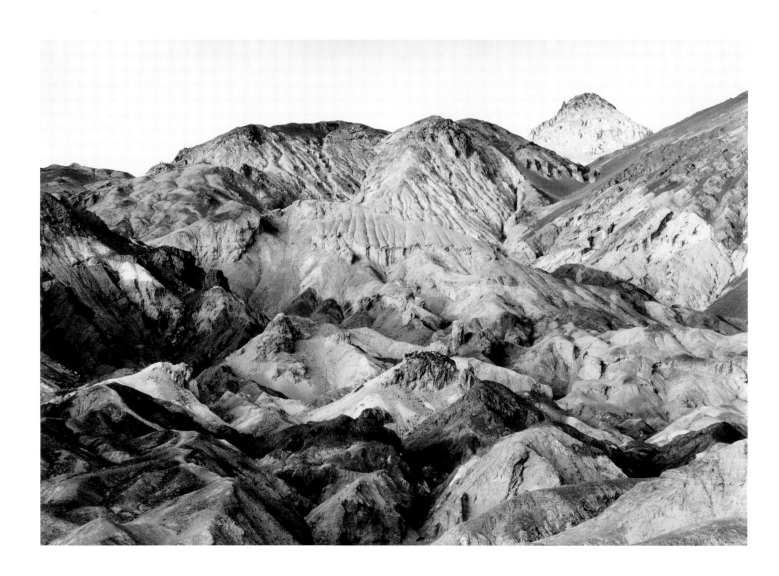

THE MENTAL LEVEL

■ You see a mental image —a mental construction —when you read this page, or look at a photograph, or see anything else in the world. Your focus even shifts when reading this picture by Paul Caponigro. But your eyes don't actually refocus (since you are only looking at a flat page). It is your mind that changes focus within your mental image of the picture, with all the attendant sensations of refocusing your eyes. It is your mental focus that is shifting.

■ Light reflecting off this page is focused by the lenses in your eyes onto your retinas. They send electrical impulses along the optic nerves to your cerebral cortex. There your brain interprets these impulses and constructs a mental image. This, surprisingly, is an acquired ability. Patients who have had their eyesight restored after having been blind from birth at first see only light. They have to learn how to construct a mental image.

■ Pictures exist on a mental level that may be coincident with the depictive level—what the picture is showing—but does not mirror it. The mental level elaborates, refines, and embellishes our perceptions of the depictive level. The mental level of a photograph provides a framework for the mental image we construct of (and for) the picture.

■ While the mental level is separate from the depictive level, it is honed by formal decisions on that level: choice of vantage point (where exactly to take the picture from), frame (what exactly to include), time (when exactly to release the shutter), and focus (what exactly to emphasize with the plane of focus). Focus is the bridge between the mental and depictive levels: focus of the lens, focus of the eye, focus of attention, focus of the mind.

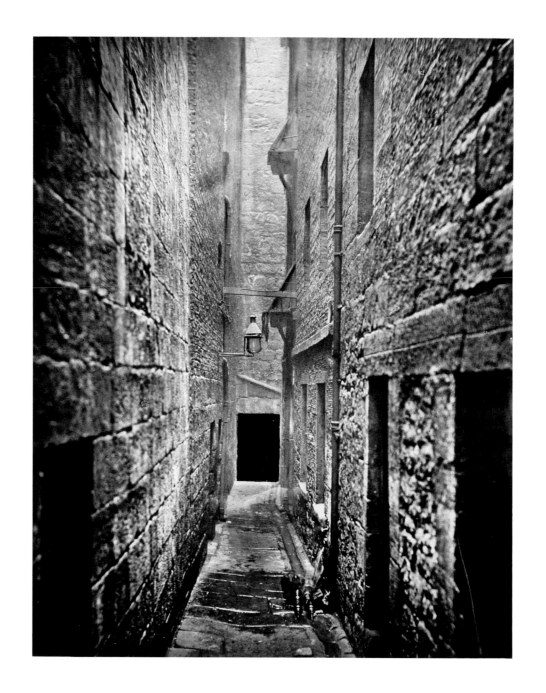

■ A photograph may have deep depictive space but shallow space on the mental level—in which there is little sensation of your eye changing focus.

■ Conversely, a photograph may have shallow depictive space but deep mental space.

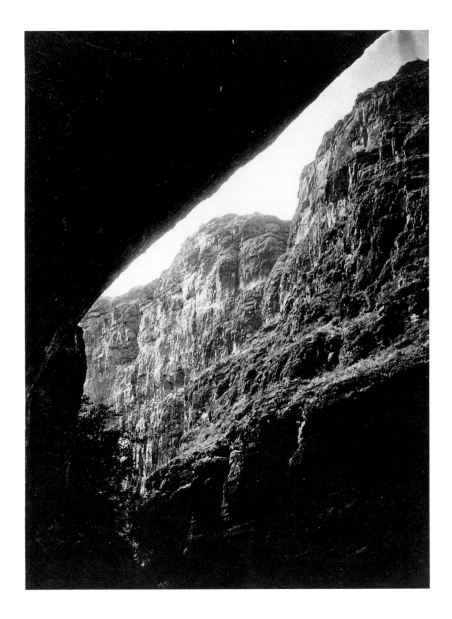

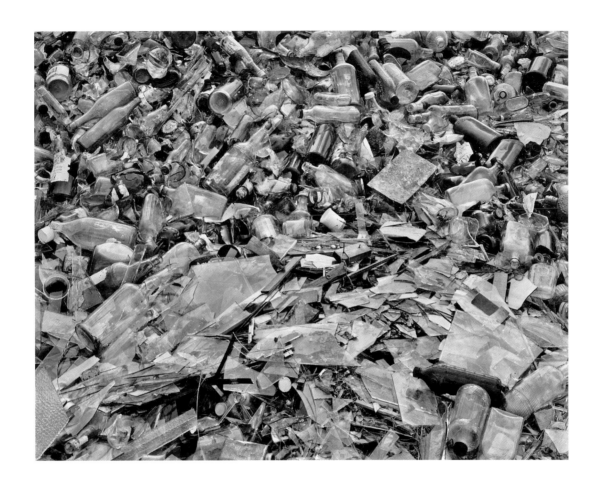

■ A photograph may utilize structural devices to emphasize deep space (layering of planes, receding diagonals, verticals in tension with the edges, and so forth) but have shallow mental space.

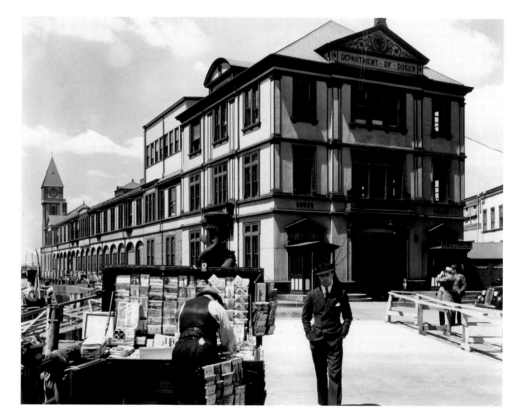

■ A photograph may have
a relatively uninflected
structure but recessive
mental space.

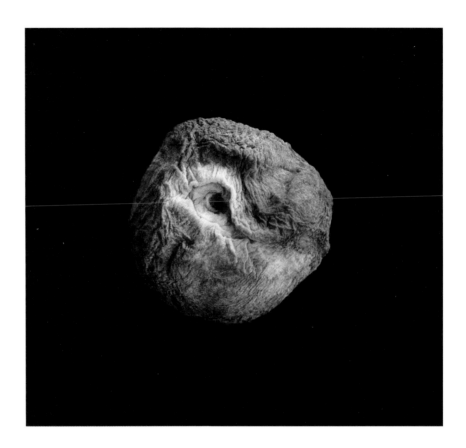

- In this Walker Evans photograph, track your focus through the space of the picture.
- Look at the sky in relation to the rest of the picture.
- Unlike the Adams photograph of the drive-in theater, where the sky moved forward, the sky here appears to float on a different plane, as though it were cut out from a different picture, as though it were a collage. This collaging appears when there is a difference in the degree of attention a photographer pays to different parts of the picture. For this to happen, the photographer needs to pay intense, clear, heightened attention to one part of the picture, but not to another.

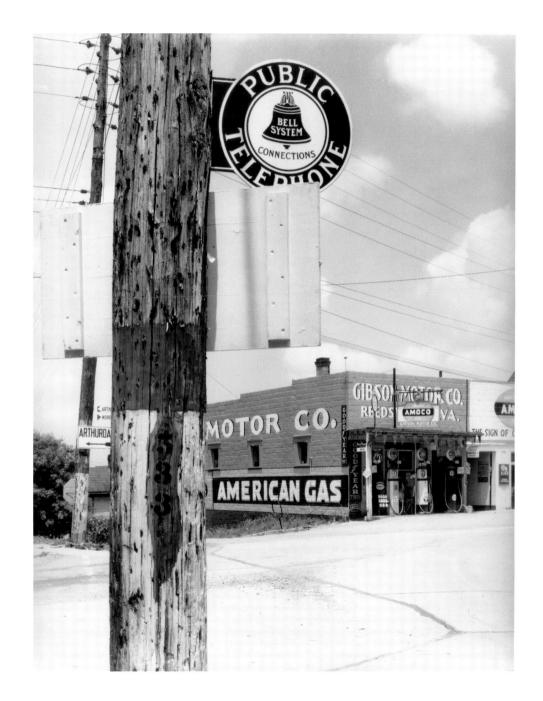

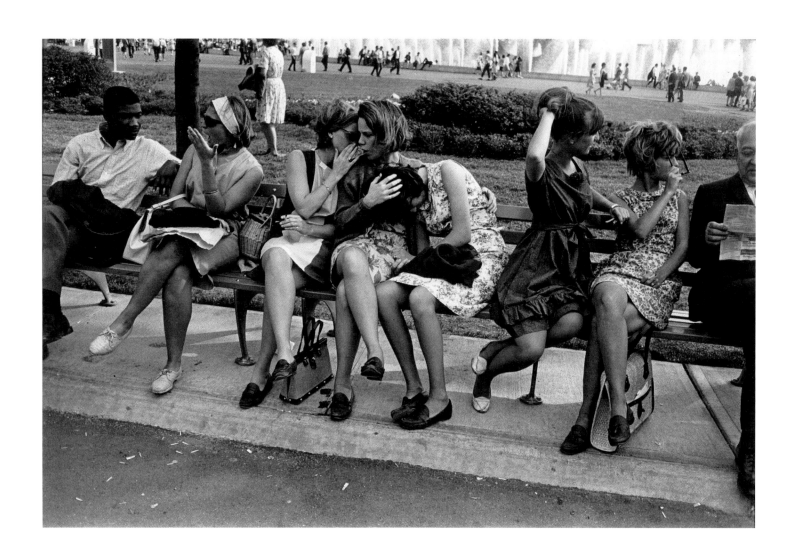

■ The quality and intensity of a photographer's attention leave their imprint on the mental level of the photograph. This does not happen by magic. A photographer's basic formal tools for defining the content and organization of a picture are vantage point, frame, focus, and time. What a photographer pays attention to governs these decisions (be they conscious, intuitive, or automatic). These decisions resonate with the clarity of the attention. They conform to the photographer's mental organization—the visual gestalt—of the picture.

■ If you right now become aware of the space between yourself and this page, there is a transmutation of your attention and perception. This sort of perceptual change—this modification of the mental image—would, for a photographer, lead to a realignment of his or her formal decisions in making a photograph.

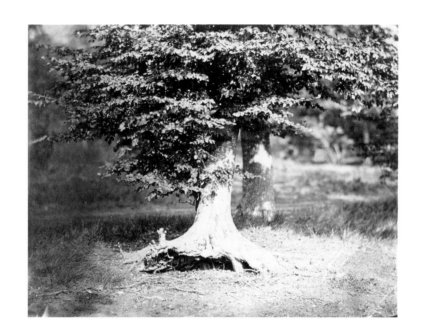

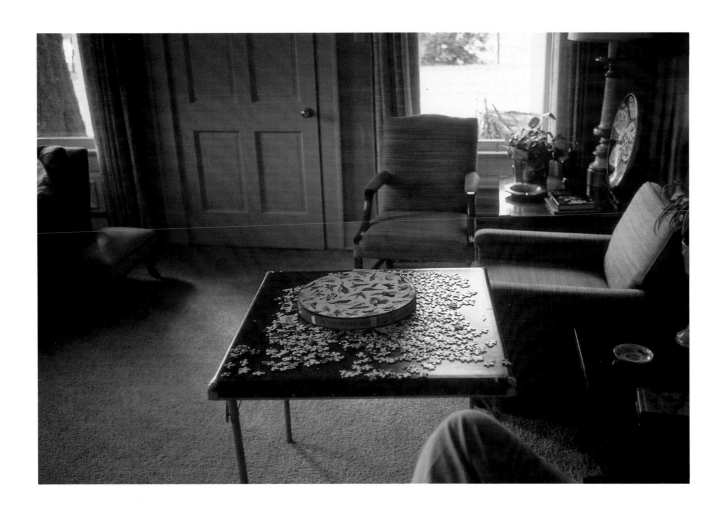

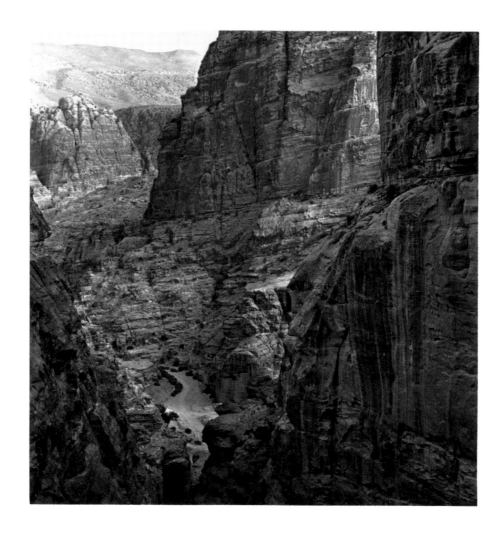

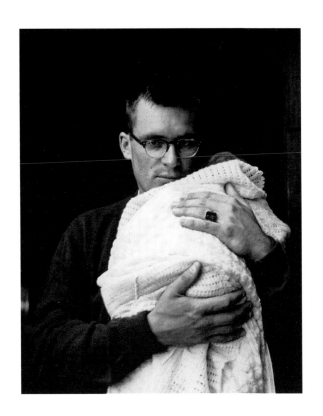

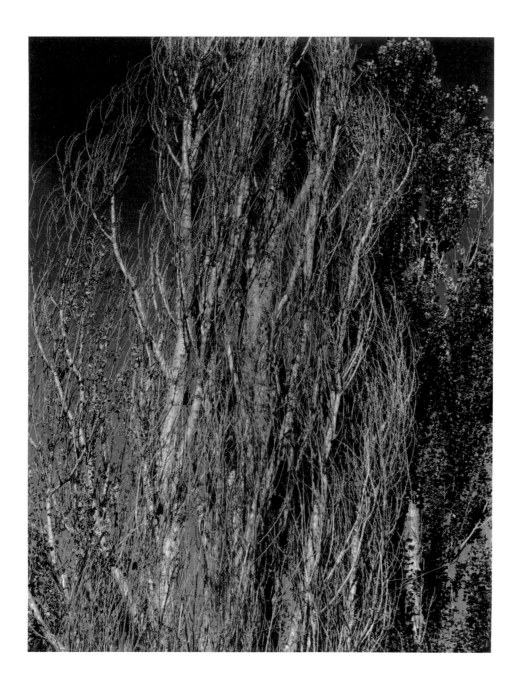

MENTAL MODELING

■ The genesis of the mental level is in the photographer's mental organization of the photograph. When photographers take pictures, they hold mental models in their minds, models that are the result of the proddings of insight, conditioning, and comprehension of the world.

■ At one extreme, the model is rigid and ossified, bound by an accumulation of its conditioning; a photographer recognizes only subjects that fit the model, or structures pictures only in accordance with the model. A rudimentary example of this is a mental filter that permits only sunsets to pass through. At the other extreme, the model is supple and fluid, readily accommodating and adjusting to new perceptions. For most photographers, the model operates unconsciously. But by making the model conscious, the photographer brings it and the mental level of the photograph under control.

■ Earlier I suggested that you become aware of the space between you and the page in this book. That caused an alteration of your mental model. You can add to this awareness by being mindful, right now, of yourself sitting in

your chair, its back press-
ing against your spine. To
this you can add an aware-
ness of the sounds in your
room. And all the while,
as your awareness is shift-
ing and your mental
model is metamorphosing,
you are reading this book,
seeing these words—
these words, which are
only ink on paper, the ink
depicting a series of funny
little symbols whose
meaning is conveyed on
the mental level. And all
the while, as your frame-
work of understanding
shifts, you continue to
read and to contemplate
the nature of photographs.

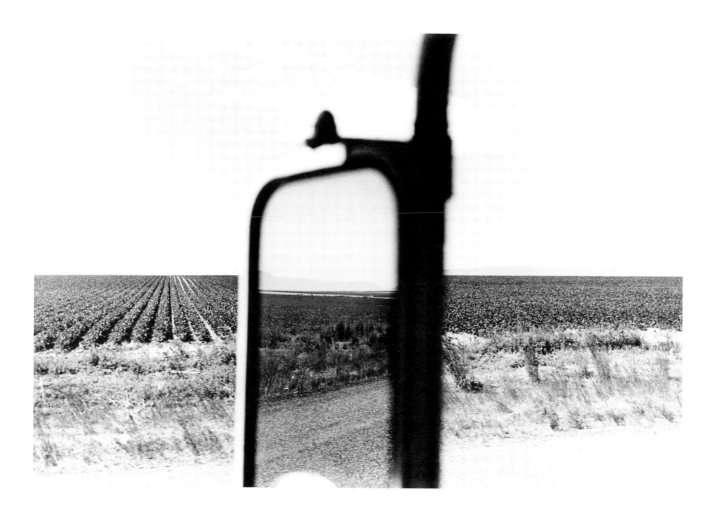

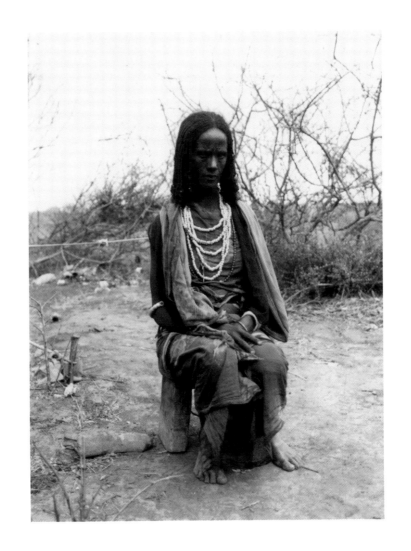

When I make a photo-
graph, my perceptions
feed into my mental
model. My model adjusts
to accommodate my per-
ceptions (leading me to
change my photographic
decisions). This modeling
adjustment in turn alters
my perceptions. And so
on. It is a dynamic, self-
modifying process. It is
what an engineer would
call a feedback loop.

It is a complex, ongoing,
spontaneous interaction of
observation, understand-
ing, imagination, and
intention.

■ Each level of a photograph is determined by attributes of the previous level. The print provides the physical framework for the visual parameters of the photographic image. The formal decisions, which themselves are a product of the nature of that image, are the tools the mental model uses to impress itself upon the picture. Each level of a photograph provides the foundation the next level builds upon. At the same time, each reflects back, enlarging the scope and meaning of the one on which it rests.

■ The mental level provides counterpoint to the depictive theme. The photographic image turns a piece of paper into a seductive illusion or a moment of truth and beauty.

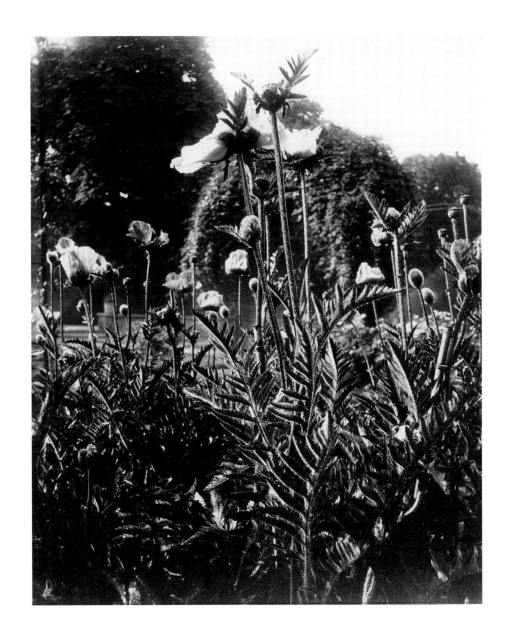

This book grew out of a course I have taught for many years at Bard College in Annandale-on-Hudson, New York. When I first started teaching the course, I used John Szarkowski's *The Photographer's Eye* (1966) as a text, and without it as a precedent *The Nature of Photographs* would not have been written.

The first draft was written while I was a fellow at the MacDowell Colony in Vermont. The combination of solitude during the day and lively conversation at dinner helped me keep my focus. The pres-

ent work evolved over several years. I am especially grateful to James L. Enyeart, Charles Hagen, and George F. Thompson for the time they took to make detailed comments on my manuscript. I am also indebted to George F. Thompson and the Center for American Places for seeing this project through to completion.

My understanding of the importance of focus was stimulated by conversations with Amos Gunsberg. For a description of the mechanics of seeing, I have referred to *Seeing with the Mind's Eye*

(1975), by Mike and Nancy Samuels.

■ Without the cooperation of all the photographers, galleries, and institutions that allowed me to reproduce work, this book would not have been possible. I particularly wish to thank Weston Naef and Anne Lyden of the Getty Museum and Peter MacGill and Laura Santaniello of PaceWildensteinMacGill.

■ Finally, I am indebted to my wife, Ginger, for her counsel and encouragement.

iv Stephen Shore, "Luzzara, Italy, 1993"

2, 4 Robert Frank, "View from Hotel Window—Butte, Montana." Copyright Robert Frank. Courtesy PaceWildensteinMacGill, New York.

7 Anne Turyn, "12 • 17 • 1960." Courtesy Anne Turyn.

9 Richard Benson, Untitled, n.d. Courtesy Richard Benson.

11 Cindy Sherman, "Untitled Film Still." Courtesy Jeff Gauntt, Metro Pictures.

12 Edourd Baldus, "View of the Pavillon Richelieu, Nouveau Louvre," ca. 1855. Collection Centre Canadien d'Architecture / Canadian Center for Architecture.

13 Bernd and Hilla Becher, "Water Towers." Courtesy of Bernd and Hilla Becher.

14 Dieter Appelt, "The Mark on the Mirror That Breathing Makes," 1977. Galerie Rudolf Kicken. Courtesy of Dieter Appelt.

15 Anonymous. Collection of Stephen and Ginger Shore.

16 Walker Evans, "Mining Town, West Virginia, 1936." Library of Congress.

19 C. E. Watkins, "Castle Rock, Columbia River, Oregon," 1868. Collection of The J. Paul Getty Museum, Los Angeles.

21 Lee Friedlander, "Knoxville, Tennessee, 1971." Courtesy Fraenkel Gallery, San Francisco.

22 André Kertész, "Dubo, Dubon, Dubonnet, Paris, 1934." Copyright Estate of André Kertész.

24 Zeke Berman, "Domestic Still Life, Art & Entropy," 1979. Copyright Zeke Berman.

25 Nicholas Nixon, "Friendly, West Virginia, 1982." Courtesy Nicholas Nixon.

26 Lisette Model, "Sammy's Bar, 1940." National Gallery of Canada, Ottawa. Courtesy PaceWildensteinMacGill, New York.

27 Aaron Diskin, "The Shadow," 1995. Courtesy Aaron Diskin.

29 Robert Adams, "Clear-cut along the Nahalem River, Tillamook County, Oregon." Courtesy Fraenkel Gallery, San Francisco.

30 Helen Levitt, "New York, ca. 1945." Copyright Helen Levitt. Courtesy Laurence Miller Gallery, New York.

33 William Eggleston, "Gulfport, Mississippi." Courtesy Winston Eggleston.

34 Stephen Shore, "El Paso Street, El Paso, Texas, 1975"

36 Garry Winogrand, "Texas State Fair, Dallas, 1964." Courtesy Fraenkel Gallery, San Francisco. Copyright the Estate of Garry Winogrand.

39 Larry Fink, "Studio 54, New York City, May 1977." Courtesy Larry Fink.

40 Linda Connor, "Sleeping Baby, Kathmandu, Nepal, 1980." Courtesy Linda Connor.

41 Edward Weston, "Pepper No. 29, 1930." Collection of The J. Paul Getty Museum, Los Angeles.

42 Tod Papageorge, "Zuma Beach, California, 1978." Courtesy Tod Papageorge.

43 Frank Gohlke, "Aftermath: the Wichita Falls, Texas, Tornado no. 10A, Maplewood Ave., near Sikes Center Mall, Looking East, April 14, 1979/ Aftermath: the Wichita Falls, Texas, Tornado no. 10B, Maplewood Ave., near Sikes Center Mall, Looking East,

June 1980." Courtesy Frank Gohlke.

44 Anonymous, [Richard Nixon the Day after the Hiss Verdict].

45 Michael Schmidt, from "Waffenruhe," 1985–87. Courtesy Michael Schmidt.

46 P. H. Emerson, "During the Reed Harvest." Collection of The J. Paul Getty Museum, Los Angeles.

49 Robert Adams, "Outdoor Theater and Cheyenne Mountain." Courtesy Fraenkel Gallery, San Francisco.

51 Jan Groover, Untitled, 1985. Courtesy Janet Borden, Inc., New York.

52 Brassaï, "Graffiti." Collection of The J. Paul Getty Museum, Los Angeles.

53 Edward Weston, "Anita, Nude I." Collection of The J. Paul Getty Museum, Los Angeles.

54 Paul Caponigro, "Death Valley, California, 1975." Copyright Paul Caponigro. Used by permission.

57 Thomas Annan, "Close, No. 61 Saltmarket." Collection of The J. Paul Getty Museum, Los Angeles.

58 William Bell, "Cañon of Kanab Wash, Colorado River, Looking South." Collection of The J. Paul Getty Museum, Los Angeles.

59 Frederick Sommer, "Glass, 1943." Copyright Frederick Sommer. Courtesy PaceWildensteinMacGill, New York.

60 Berenice Abbott, "Department of Docks, New York City, 1936." Berenice Abbott / Commerce Graphics Ltd., Inc.

61 Paul Caponigro, "Peach, Santa Fe, New Mexico, 1989." Copyright Paul Caponigro. Used by permission.

63 Walker Evans, "Gas Station, Reedsville, West Virginia, 1936." Library of Congress.

64 Garry Winogrand, "World's Fair, New York City, 1964." Courtesy Fraenkel Gallery, San Francisco. Copyright The Estate of Garry Winogrand.

66 Gustave Le Gray, "The Beech Tree," ca. 1856. Collection of The J. Paul Getty Museum, Los Angeles.

67 William Eggleston, "Tallahatchie County, Mississippi." Courtesy Winston Eggleston.

68 Emmet Gowin, "Wadi, Siyagh, Petra, Jordan," 1982. Courtesy Emmet Gowin.

69 Dorothea Lange, "Second Born, Berkeley, 1955." Courtesy the Dorothea Lange Collection, The Oakland Museum. Gift of Paul S. Taylor.

70 Alfred Stieglitz, "Poplars, Lake George, 1932." George Eastman House. Courtesy the Georgia O'Keefe Foundation.

72 Diane Arbus, "Woman on a Park Bench on a Sunny Day, N.Y.C., 1969." Copyright Estate of Diane Arbus, 1972. Courtesy Robert Miller Gallery, New York.

73 Lee Friedlander, "Idaho 1972." Courtesy Fraenkel Gallery, San Francisco.

74 Fazal Sheikh, "Darmi Halake Gilo, Sololo, Kenya, 1992–93." Courtesy Fazal Sheikh.

75 Frederick Sommer, "Virgin and Child with St. Anne and the Infant St. John, 1966." Copyright Frederick Sommer. Courtesy PaceWildensteinMacGill, New York.

77 Stephen Shore, "Muna, Mexico, 1990."

79 Eugène Atget, "Oriental Poppy," n.d. Collection of Stephen and Ginger Shore.

Stephen Shore's work has been widely published and exhibited for the past twenty-five years. He was the first living photographer to have a one-man show at the Metropolitan Museum of Art in New York City. He has also had one-man shows at the Museum of Modern Art, the Art Institute of Chicago, the George Eastman House in Rochester, New York, and the Kunsthalle in Dusseldorf, Germany, and he has received fellowships from the John Simon Guggenheim Memorial Foundation and the National Endowment for the Arts. His series of exhibitions at Light Gallery in New York City in the early 1970s sparked interest in color photography and led to the rebirth of the use of the view camera for documentary work. Aperture has published two monographs of his photographs, *Uncommon Places* (1982) and *The Gardens at Giverny* (1983). In 1993 Arcadia Edizioni published *Stephen Shore: Luzzara. The Velvet Years*, a book of his photographs of Andy Warhol and the Velvet Underground from 1965 through 1967, came out in 1995.

That same year, Schirmer/ Mosel published *Stephen Shore: Photographs, 1973–1993*, a retrospective monograph. Since 1982 he has been the chairman of the photography department at Bard College, where he is the Susan Weber Soros Professor in the Arts. He is represented by PaceWildensteinMacGill in New York City.

■ Collections include the Museum of Modern Art; Metropolitan Museum of Art; Art Institute of Chicago; George Eastman House; Library of Congress, Washington, D.C.; San Francisco Museum of Modern Art; Whitney Museum of American Art, New York City; Los Angeles County Museum of Art; Australian National Gallery, Canberra; Neue Sammlung, Munich, Germany; Canadian Centre for Architecture, Montreal; Stedlijk Museum, Amsterdam, The Netherlands; Royal Library, Copenhagen, Denmark; and Moderna Museet, Stockholm